Paisley Patterns

COLORING BOOK

CALMING COLORING BOOKS FOR ADULTS

Coloring Therapists
STRESS RELIEVING COLORING ACTIVITIES

Coloring Therapists LLC
40 E. Main St. #1156
Newark, DE 19711
www.coloringtherapists.com

Copyright 2016

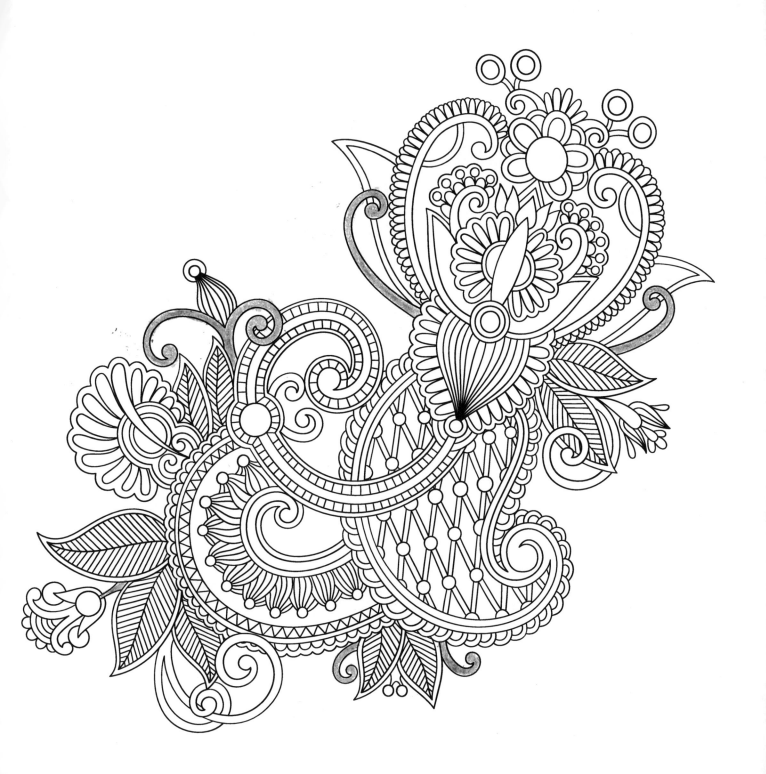

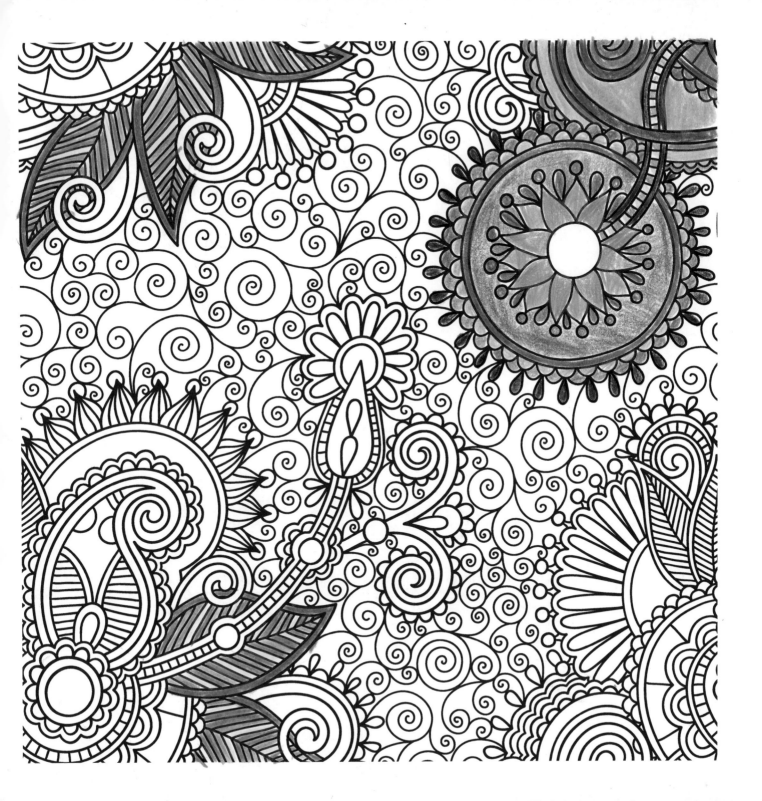

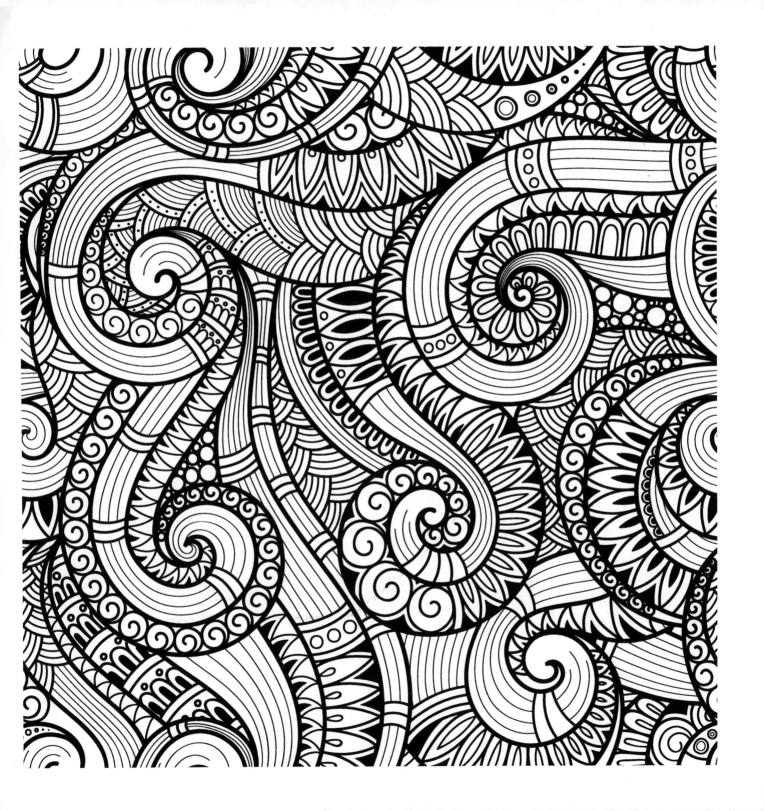

This is a Bleed Through Page If You Are Using a Coloring Marker or Pen!

Find Other Great Titles By searching for <u>*Coloring Therapists*</u> *on Your Favorite Book Retailer*

Amazon.Com | Barnes & Noble (BN.Com) | Books A Million (BAM.Com)

Coloring Therapists

STRESS RELIEVING COLORING ACTIVITIES

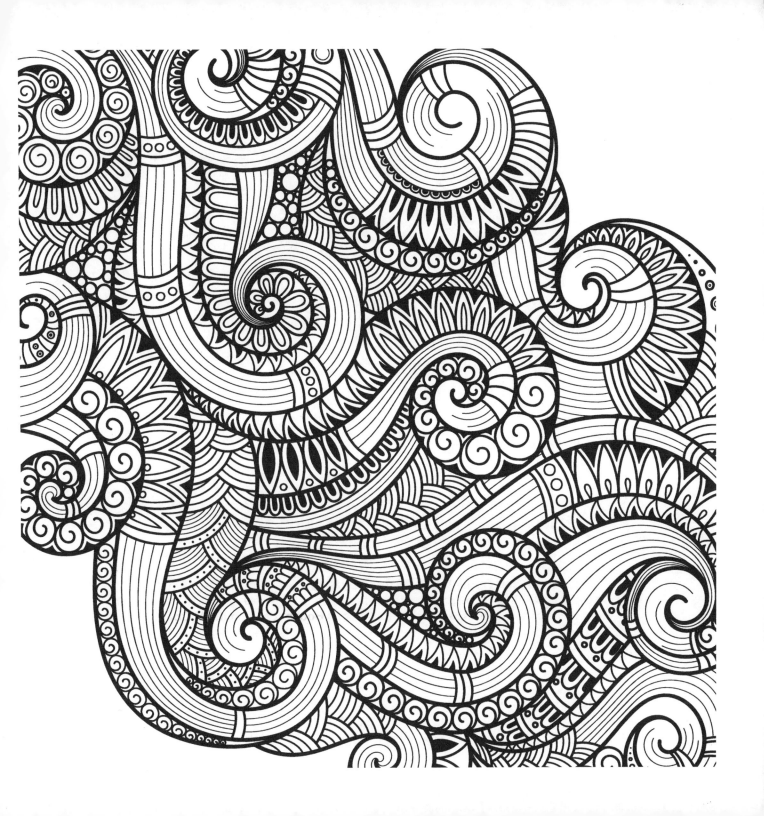

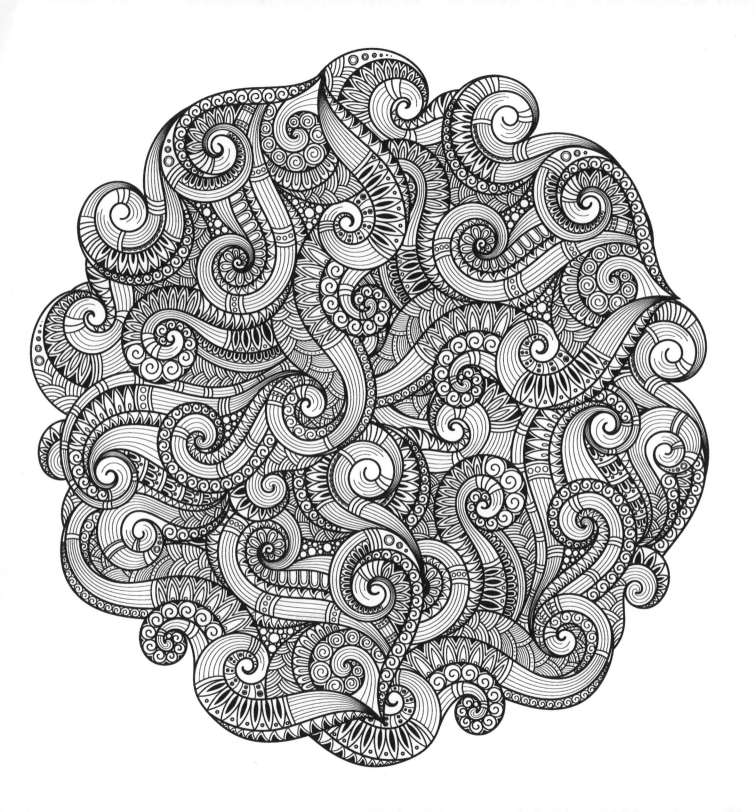

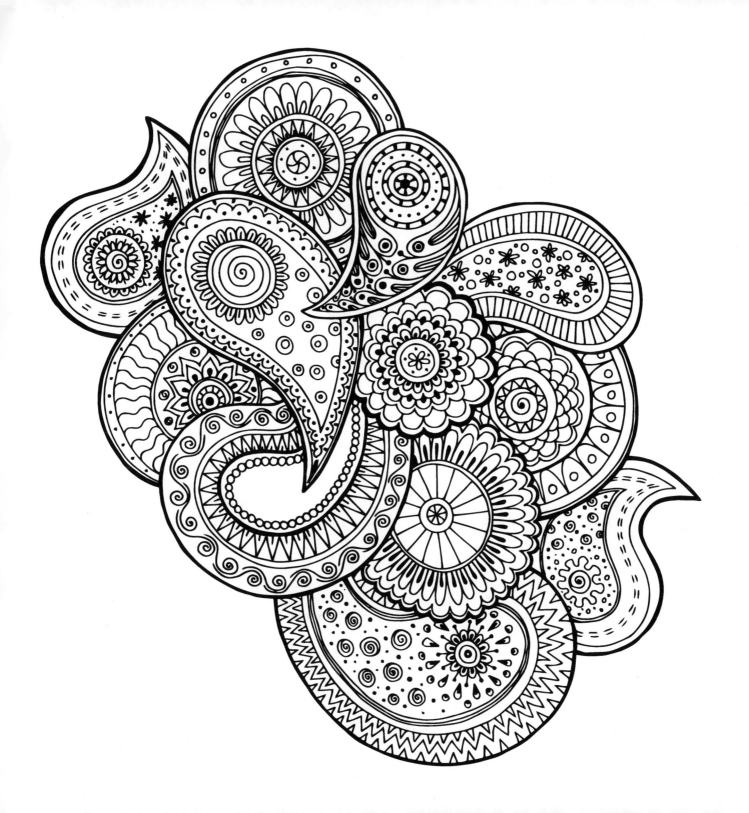

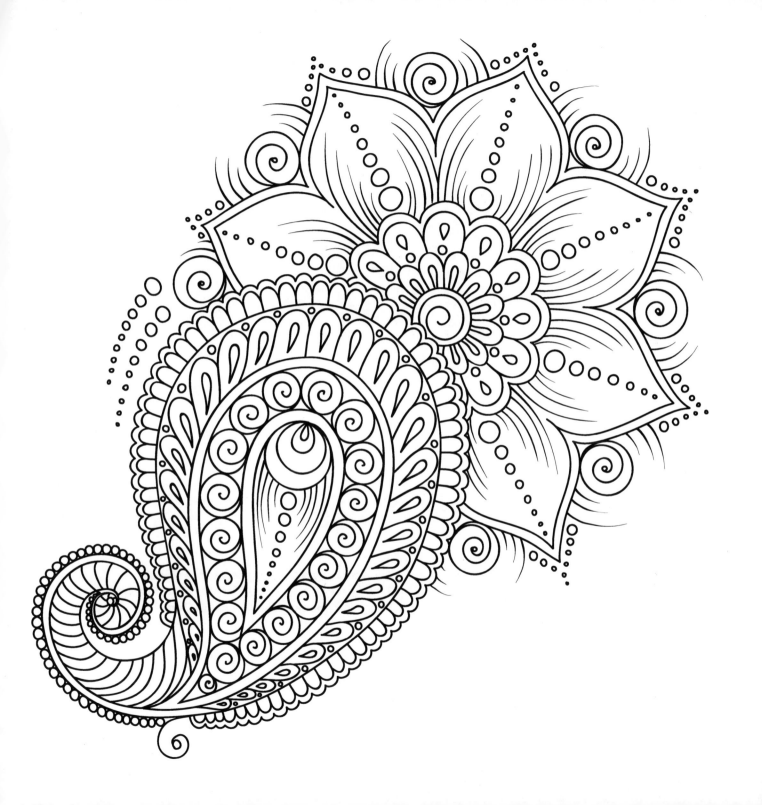

This is a Bleed Through Page If You Are Using a Coloring Marker or Pen!
Find Other Great Titles By searching for Coloring Therapists on Your Favorite Book Retailer
Amazon.Com | Barnes & Noble (BN.Com) | Books A Million (BAM.Com)

Coloring Therapists
STRESS RELIEVING COLORING ACTIVITIES

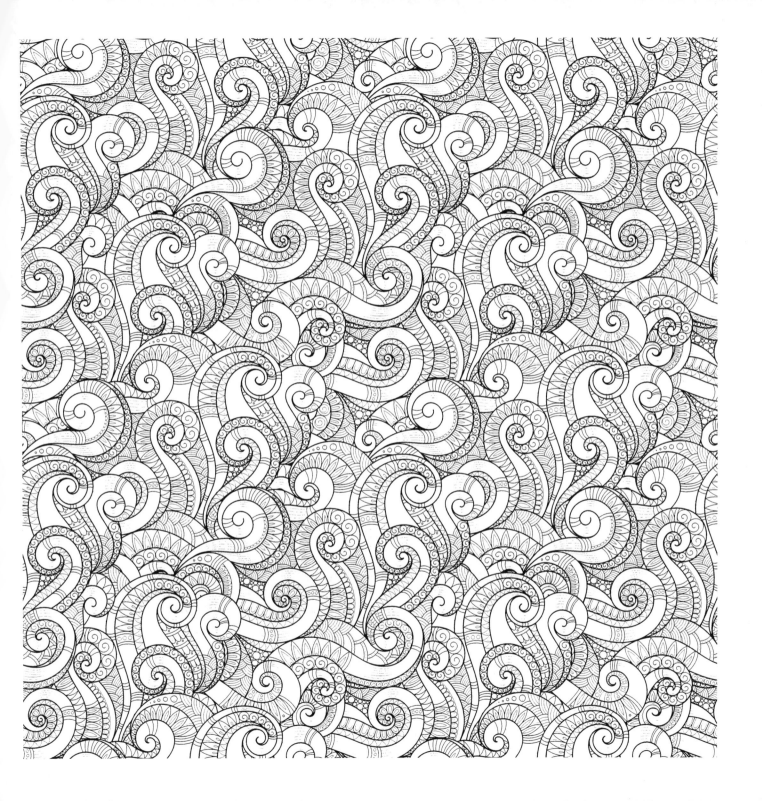

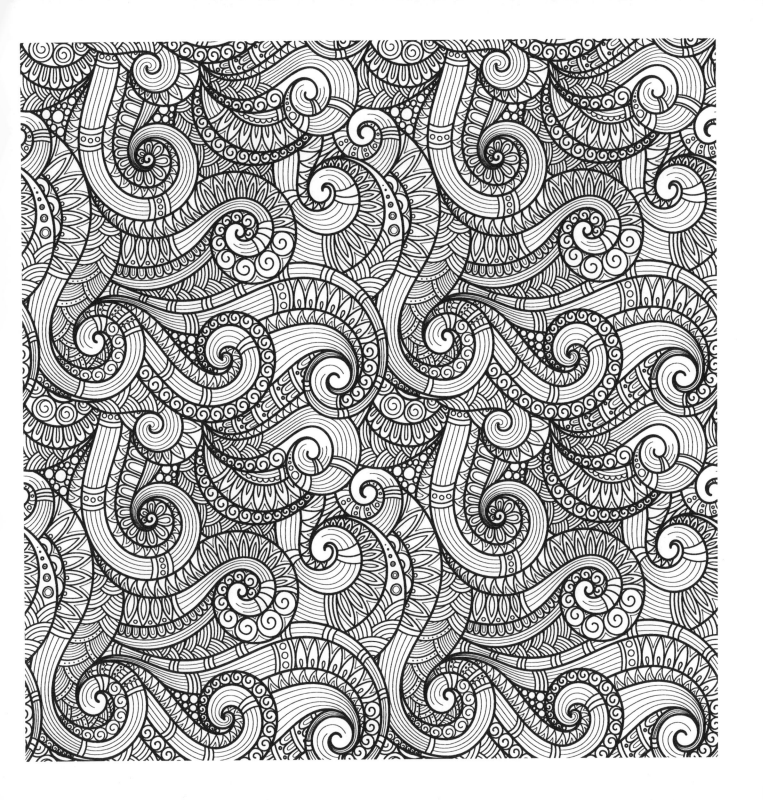

This is a Bleed Through Page If You Are Using a Coloring Marker or Pen!
Find Other Great Titles By searching for <u>*Coloring Therapists*</u> *on Your Favorite Book Retailer*
Amazon.Com | Barnes & Noble (BN.Com) | Books A Million (BAM.Com)

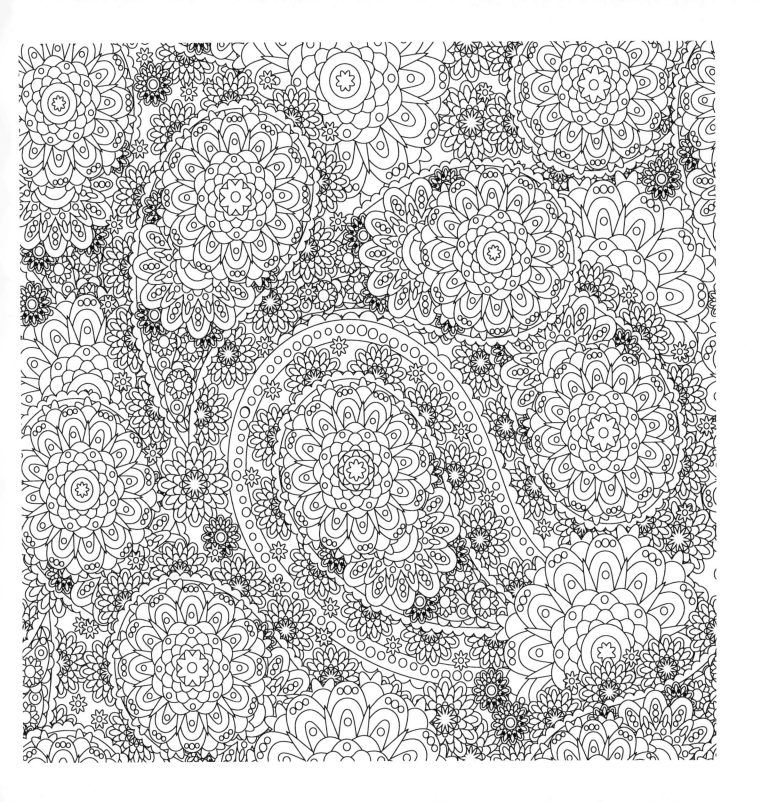

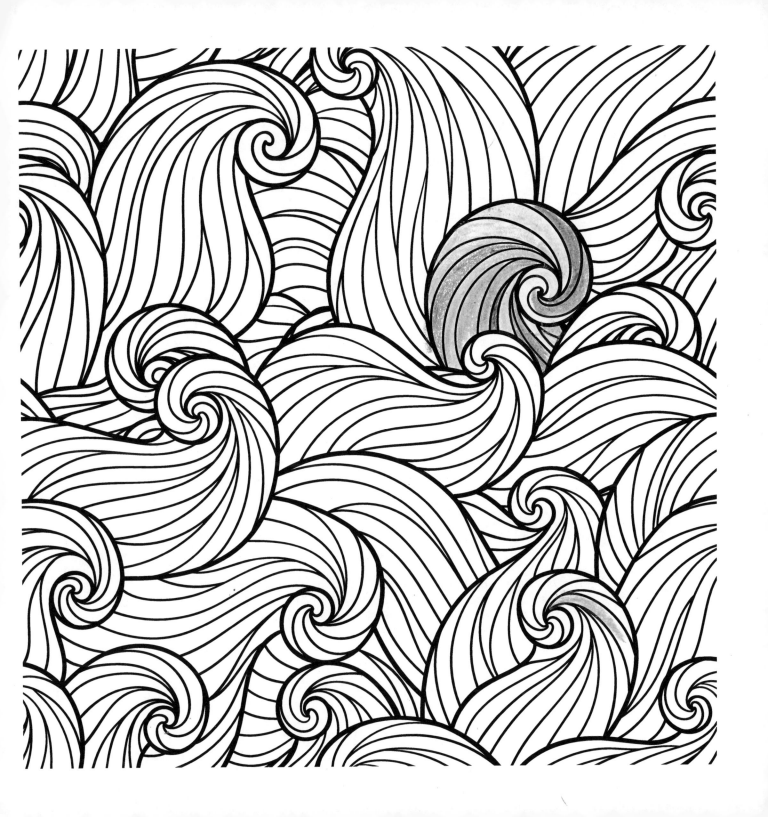

This is a Bleed Through Page If You Are Using a Coloring Marker or Pen!
Find Other Great Titles By searching for Coloring Therapists on Your Favorite Book Retailer
Amazon.Com | Barnes & Noble (BN.Com) | Books A Million (BAM.Com)

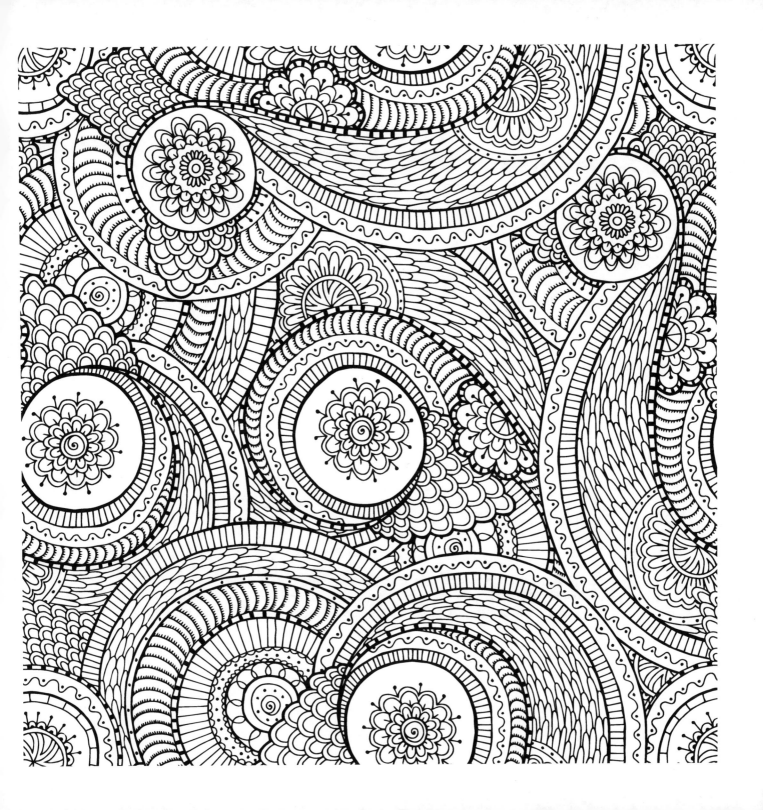

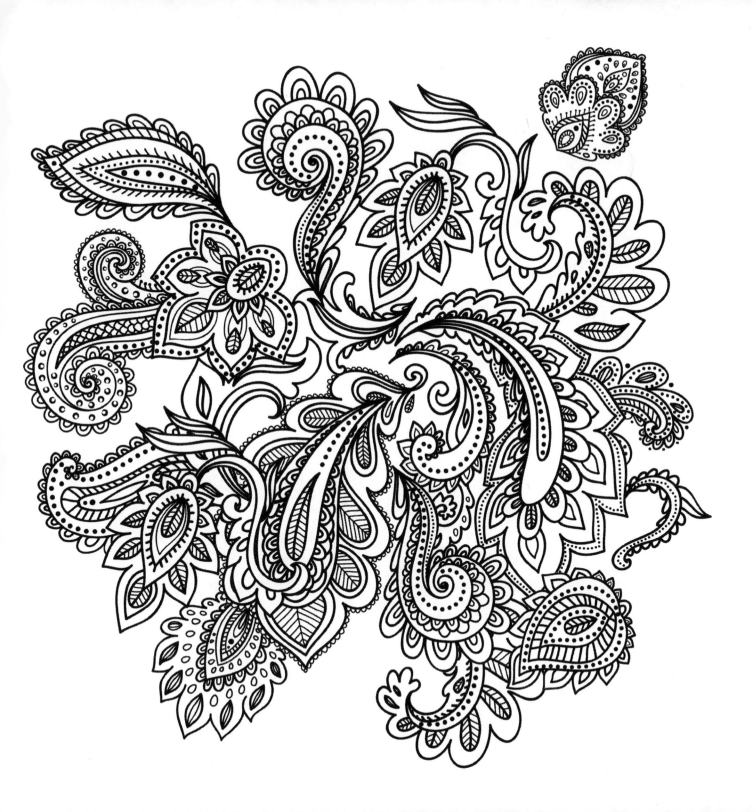

This is a Bleed Through Page If You Are Using a Coloring Marker or Pen!
Find Other Great Titles By searching for Coloring Therapists on Your Favorite Book Retailer
Amazon.Com | Barnes & Noble (BN.Com) | Books A Million (BAM.Com)

Coloring Therapists
STRESS RELIEVING COLORING ACTIVITIES

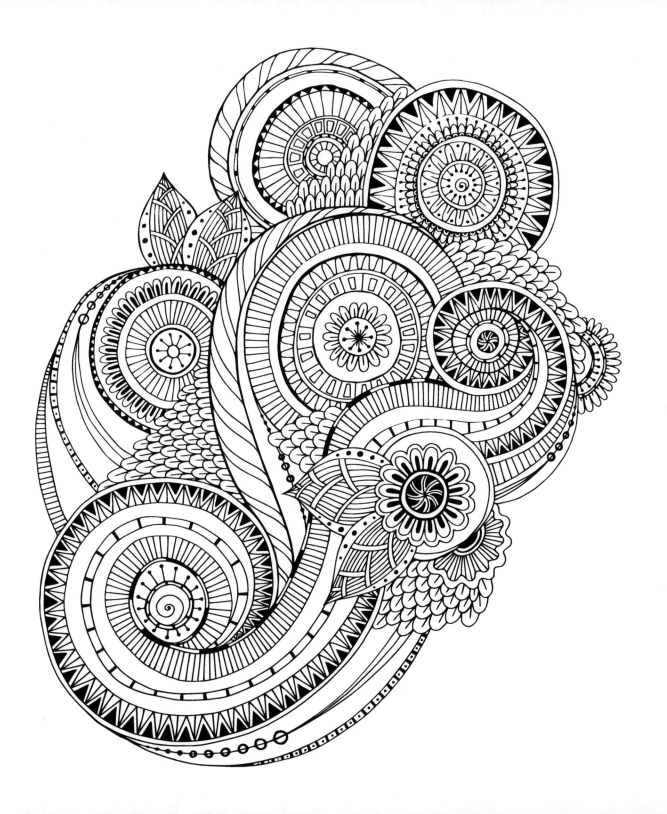

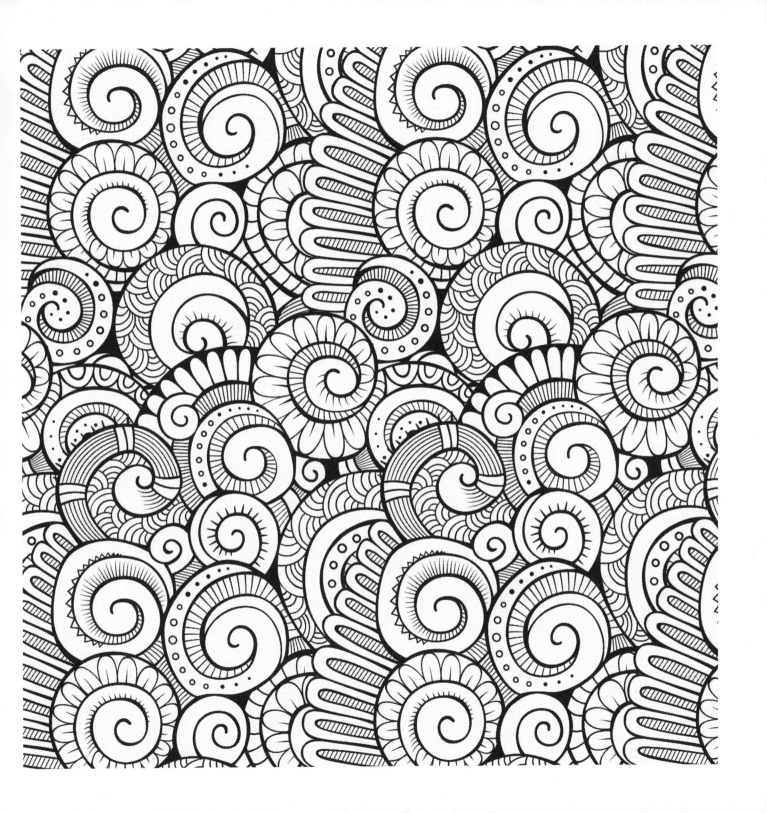

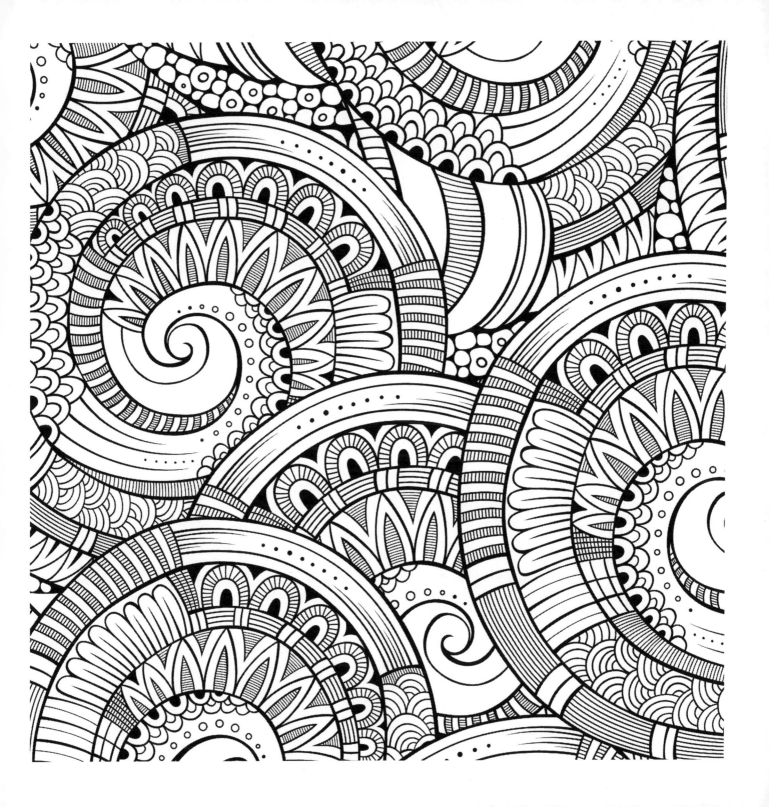

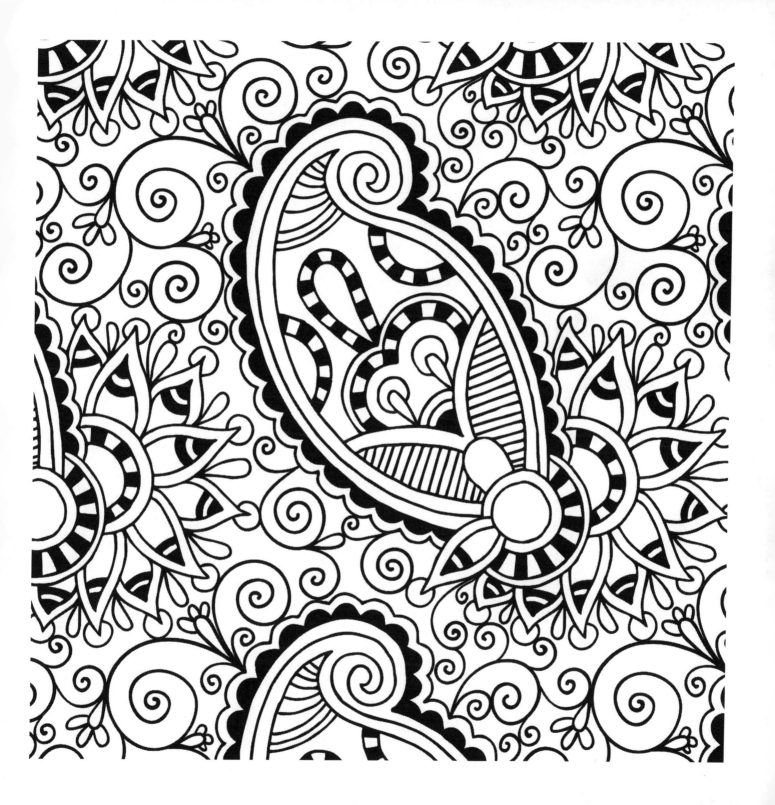

This is a Bleed Through Page If You Are Using a Coloring Marker or Pen!
Find Other Great Titles By searching for Coloring Therapists on Your Favorite Book Retailer
Amazon.Com | Barnes & Noble (BN.Com) | Books A Million (BAM.Com)

Coloring Therapists
STRESS RELIEVING COLORING ACTIVITIES

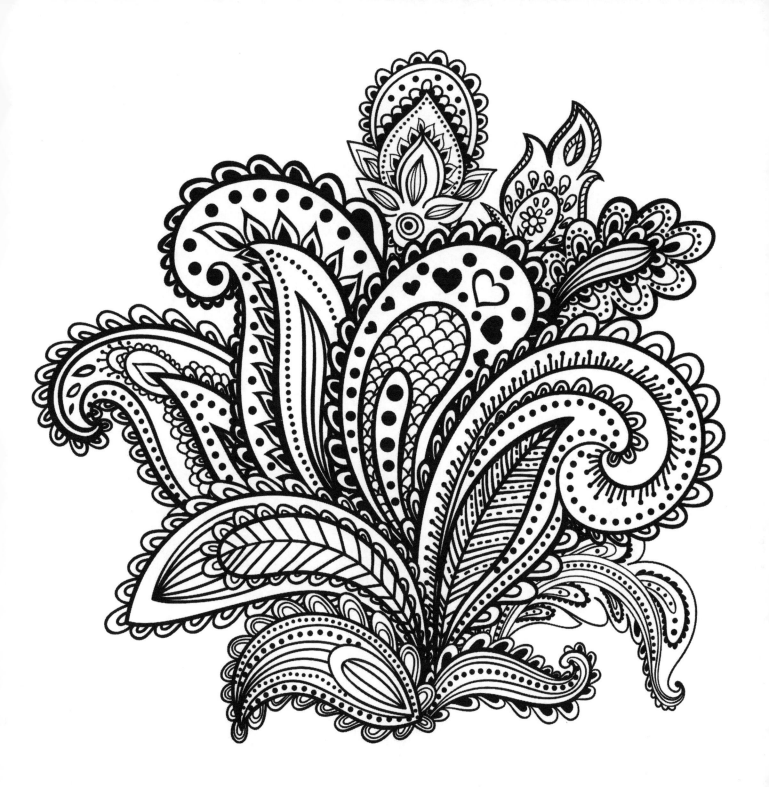

This is a Bleed Through Page If You Are Using a Coloring Marker or Pen!
Find Other Great Titles By searching for Coloring Therapists on Your Favorite Book Retailer
Amazon.Com | Barnes & Noble (BN.Com) | Books A Million (BAM.Com)

Coloring Therapists
STRESS RELIEVING COLORING ACTIVITIES

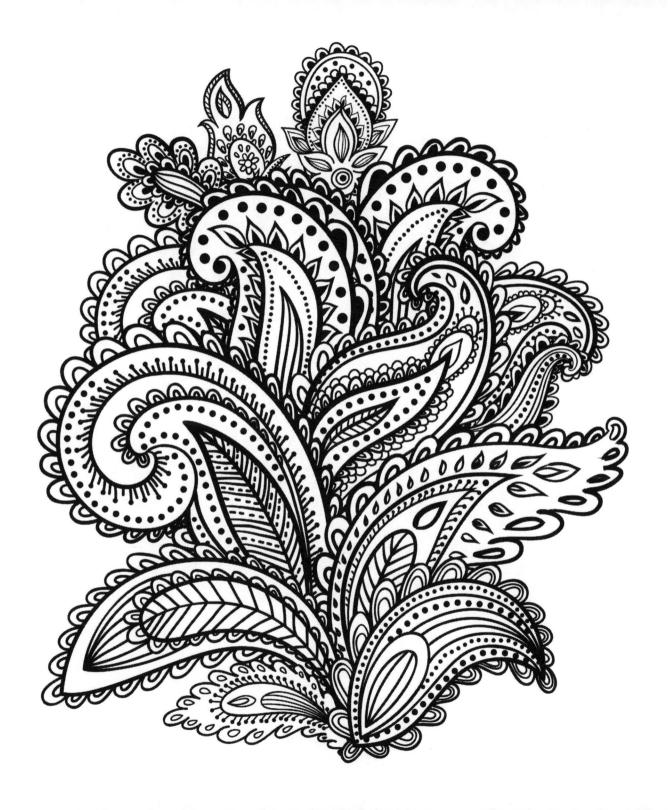

This is a Bleed Through Page If You Are Using a Coloring Marker or Pen!
Find Other Great Titles By searching for Coloring Therapists on Your Favorite Book Retailer
Amazon.Com | Barnes & Noble (BN.Com) | Books A Million (BAM.Com)

Coloring Therapists

STRESS RELIEVING COLORING ACTIVITIES

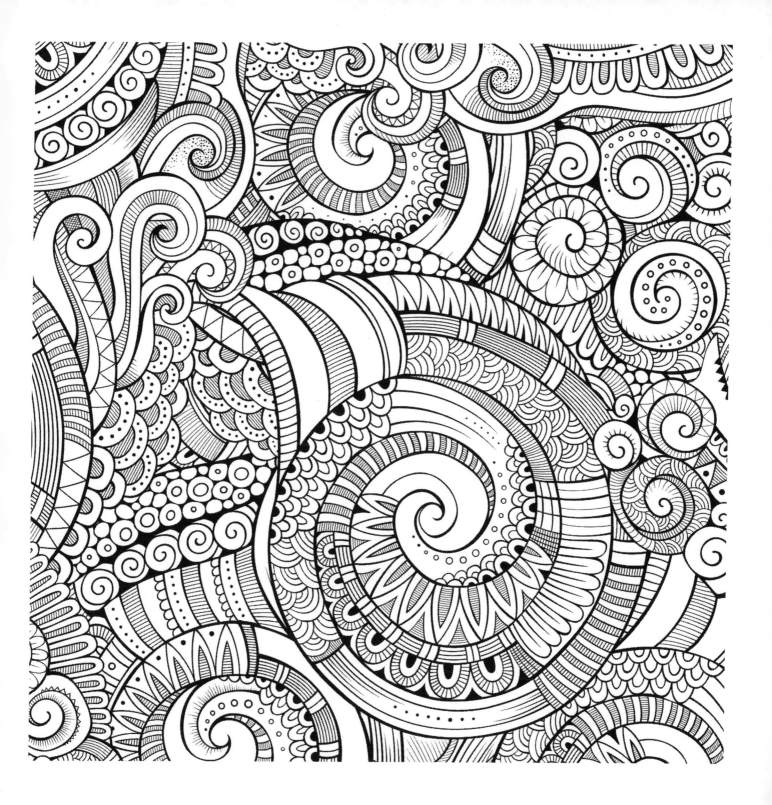

This is a Bleed Through Page If You Are Using a Coloring Marker or Pen!
Find Other Great Titles By searching for <u>Coloring Therapists</u> *on Your Favorite Book Retailer*
Amazon.Com | Barnes & Noble (BN.Com) | Books A Million (BAM.Com)

Coloring Therapists
STRESS RELIEVING COLORING ACTIVITIES

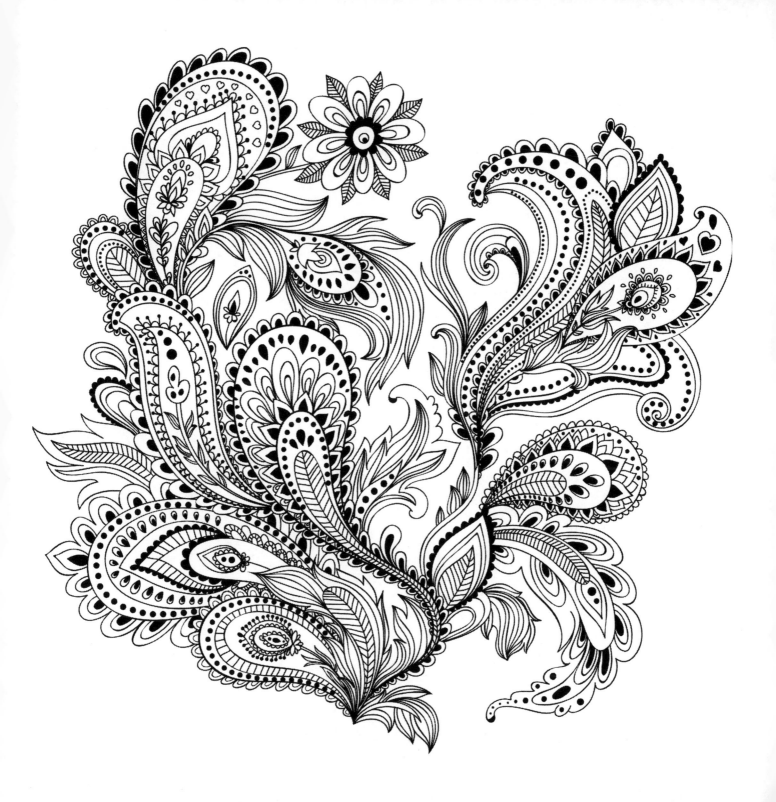

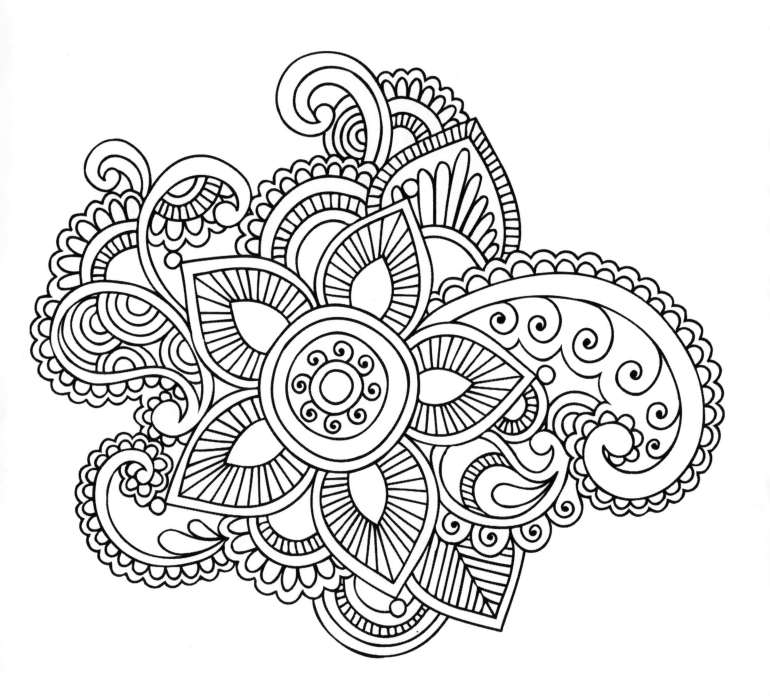

This is a Bleed Through Page If You Are Using a Coloring Marker or Pen!
Find Other Great Titles By searching for Coloring Therapists on Your Favorite Book Retailer
Amazon.Com | Barnes & Noble (BN.Com) | Books A Million (BAM.Com)

Coloring Therapists
STRESS RELIEVING COLORING ACTIVITIES

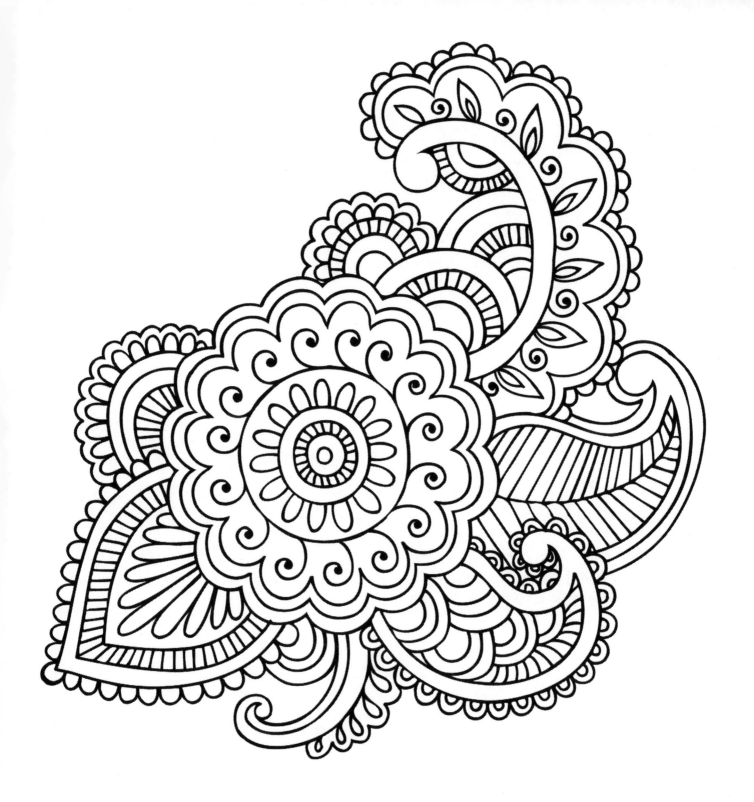

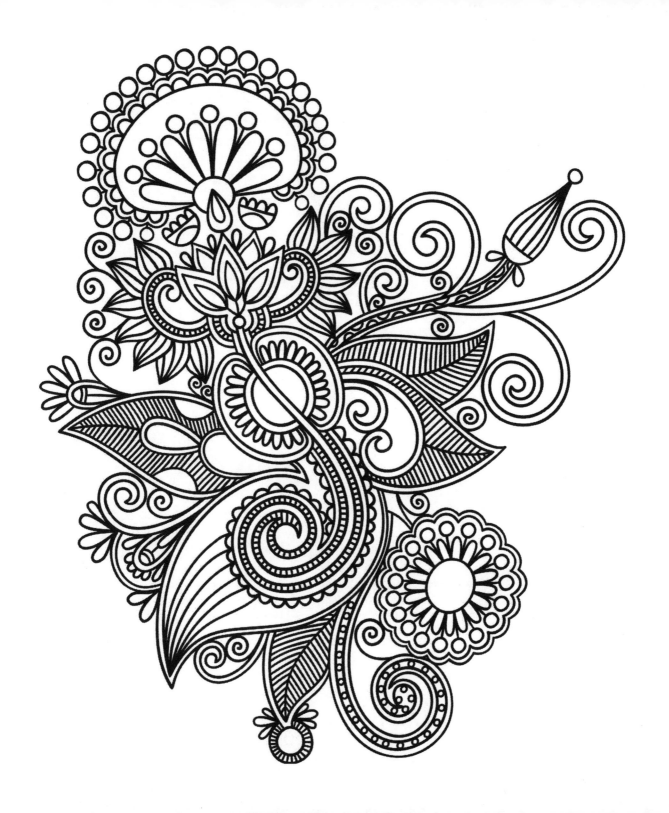

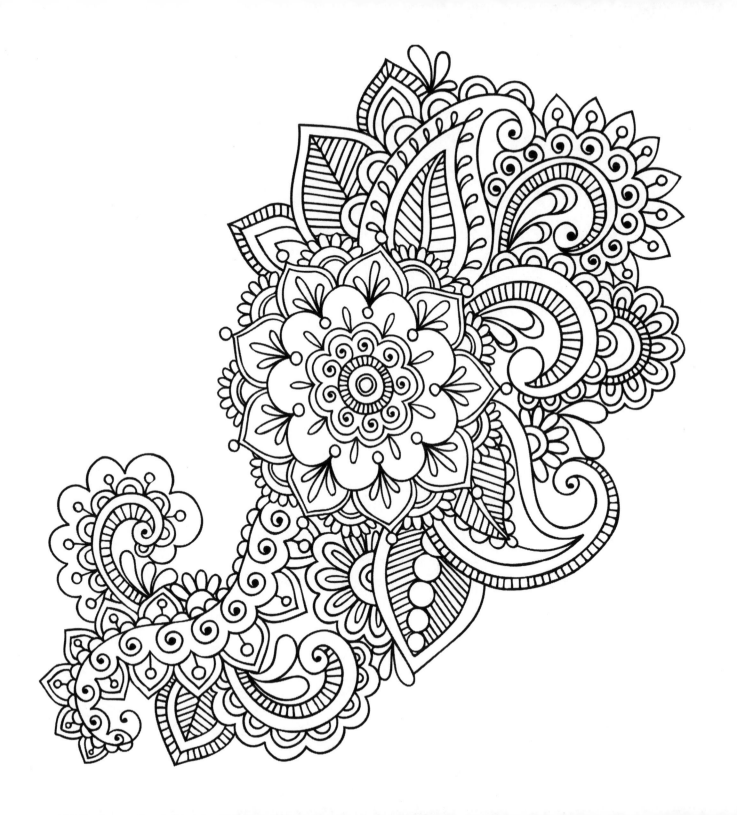

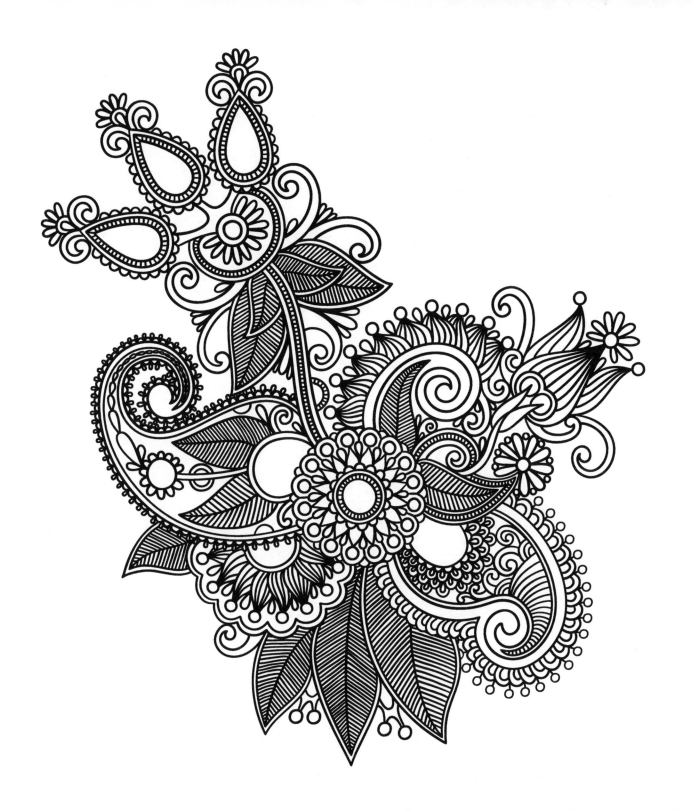

This is a Bleed Through Page If You Are Using a Coloring Marker or Pen!
Find Other Great Titles By searching for Coloring Therapists on Your Favorite Book Retailer
Amazon.Com | Barnes & Noble (BN.Com) | Books A Million (BAM.Com)

Coloring Therapists
STRESS RELIEVING COLORING ACTIVITIES

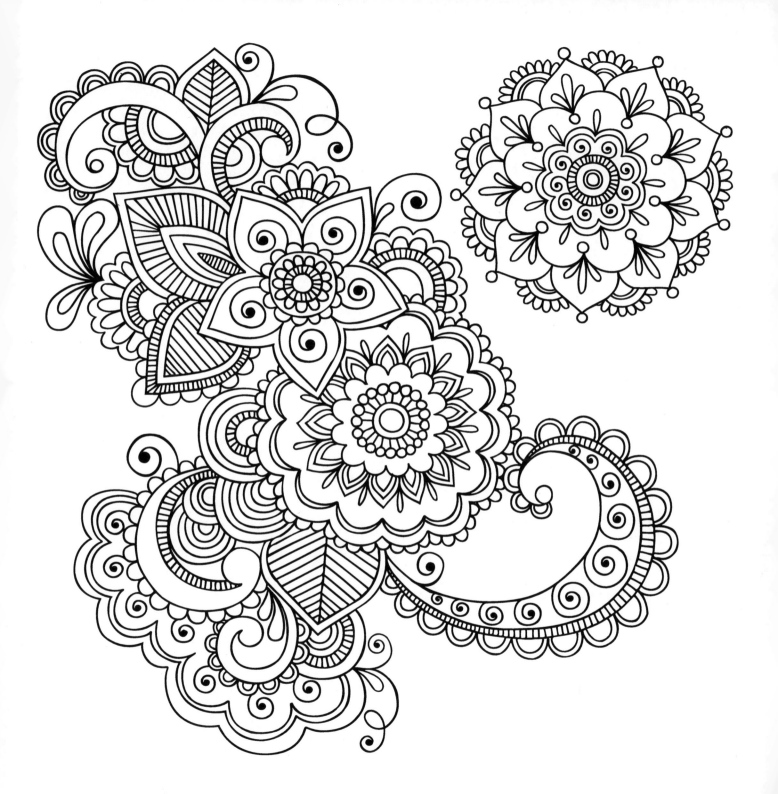

This is a Bleed Through Page If You Are Using a Coloring Marker or Pen!
Find Other Great Titles By searching for <u>Coloring Therapists</u> on Your Favorite Book Retailer
Amazon.Com | Barnes & Noble (BN.Com) | Books A Million (BAM.Com)

Coloring Therapists
STRESS RELIEVING COLORING ACTIVITIES

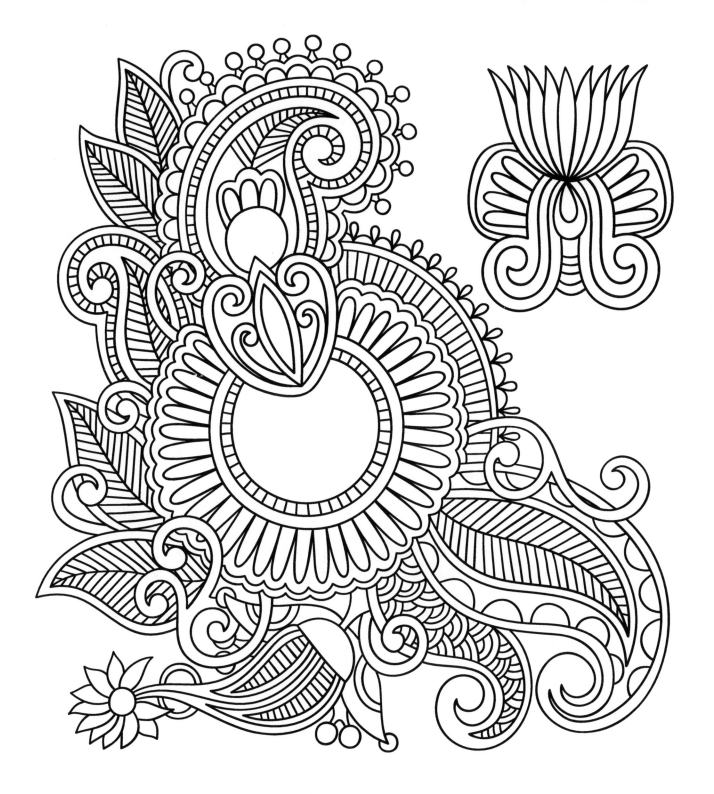

This is a Bleed Through Page If You Are Using a Coloring Marker or Pen!
Find Other Great Titles By searching for Coloring Therapists on Your Favorite Book Retailer
Amazon.Com | Barnes & Noble (BN.Com) | Books A Million (BAM.Com)

Coloring Therapists
STRESS RELIEVING COLORING ACTIVITIES

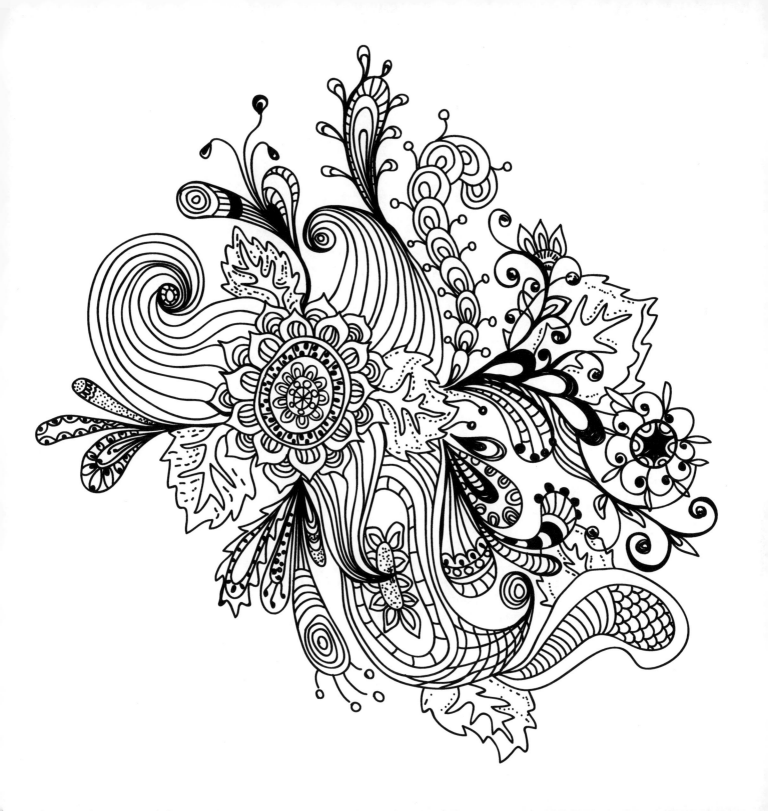

This is a Bleed Through Page If You Are Using a Coloring Marker or Pen!
Find Other Great Titles By searching for <u>Coloring Therapists</u> *on Your Favorite Book Retailer*
Amazon.Com | Barnes & Noble (BN.Com) | Books A Million (BAM.Com)

Coloring Therapists
STRESS RELIEVING COLORING ACTIVITIES

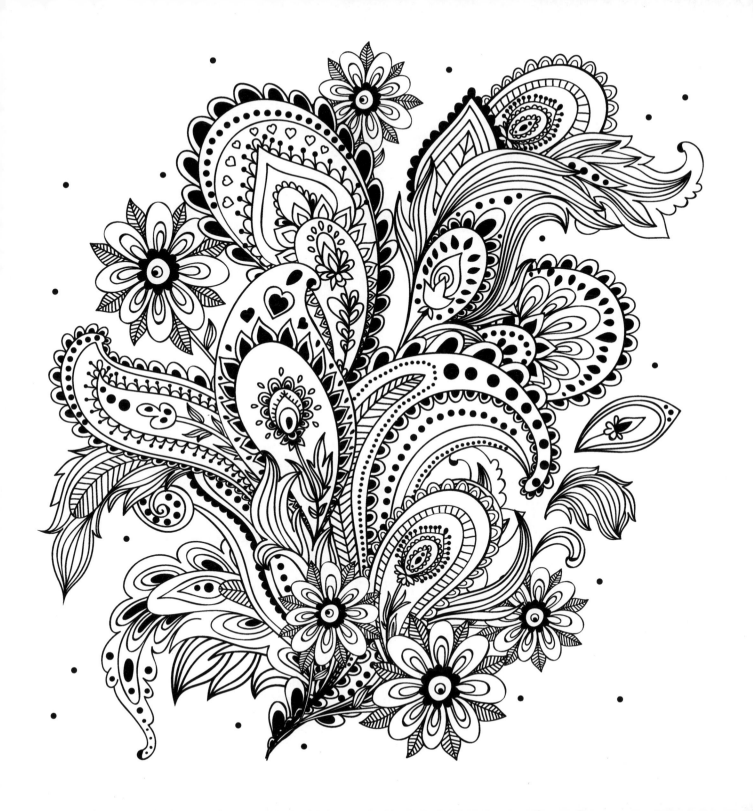

Made in the USA
Middletown, DE
17 July 2018